It's Fall

by
Jimmy Pickering

smallfell⌣w press
LOS ANGELES

To Leota
(Mother Nature in a limo)

Thank you for showing me that each new season is a special gift

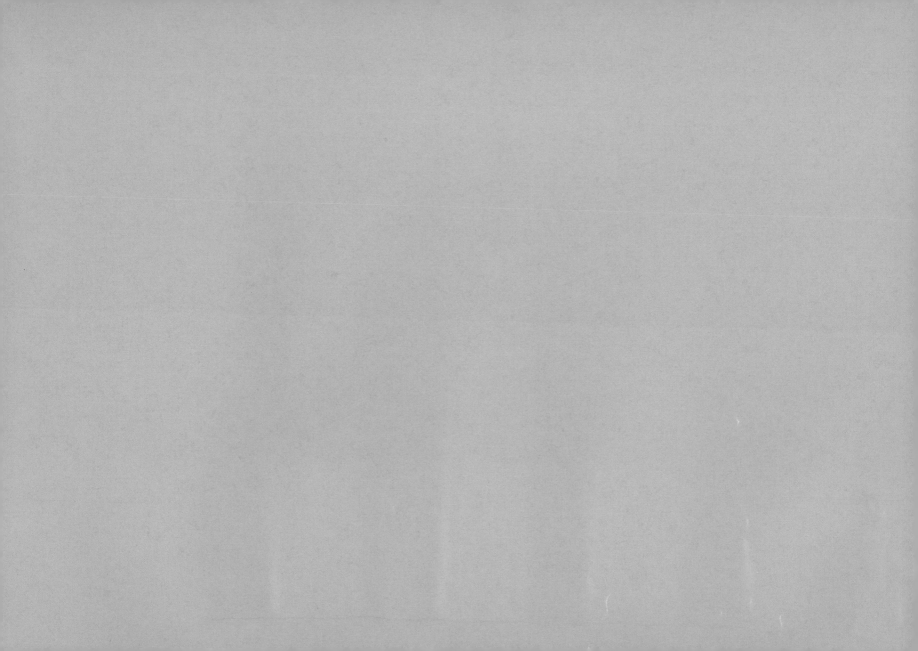

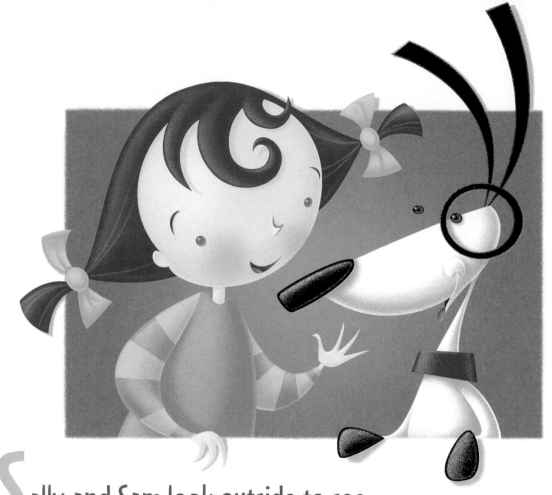

Sally and Sam look outside to see
A chilly wind whistling through their big tree.

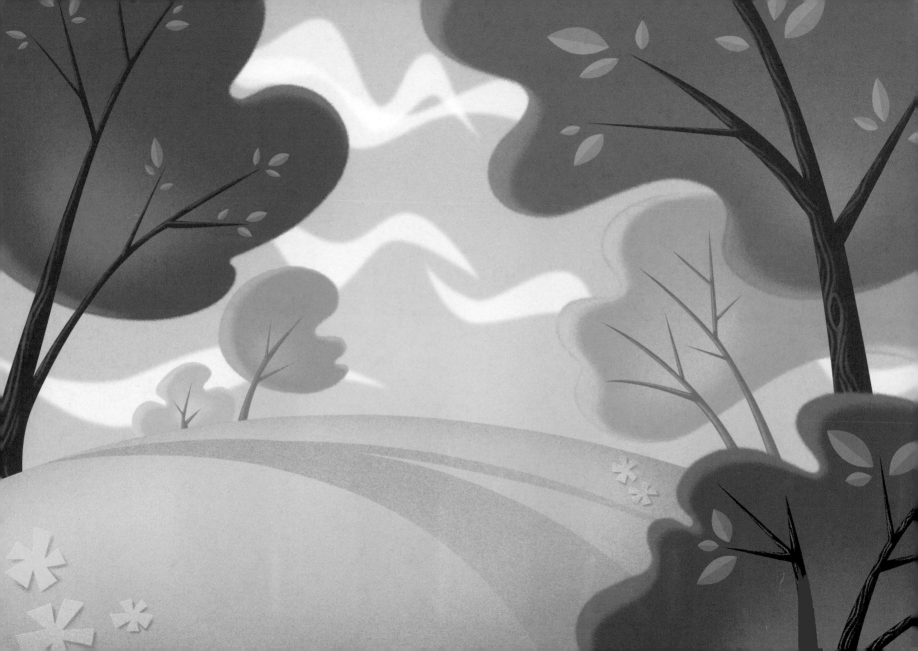

The leaves that were green,
High over their heads,
Are now full of yellows
And ambers and reds.

The seasons have changed;
Now they want to see
What new things they'll find
And what fun Fall can be.

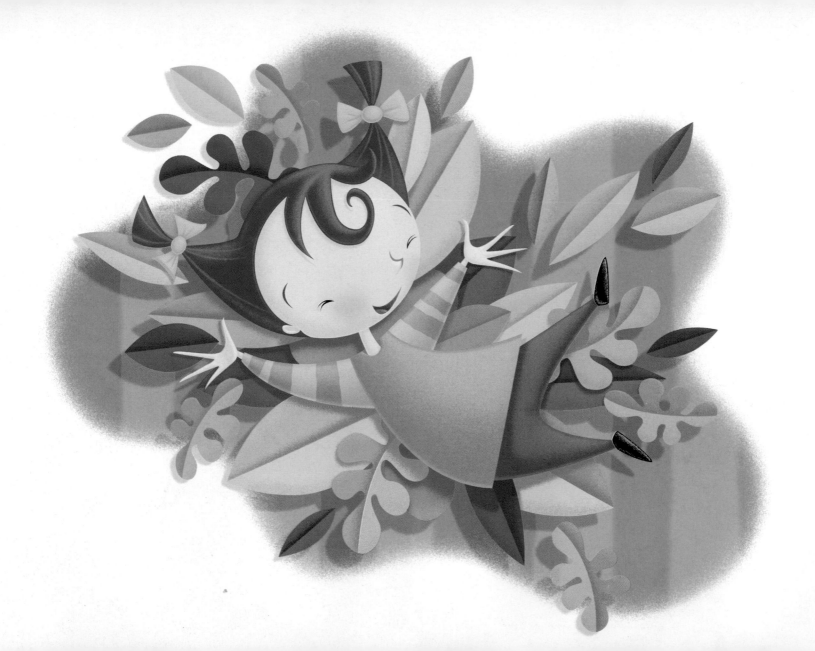

Some leaves that have fallen are put into sacks
While others are piled in very tall stacks.

They jump on the ground
And leap in the air.

They laugh when they see
Leaves stuck in their hair.

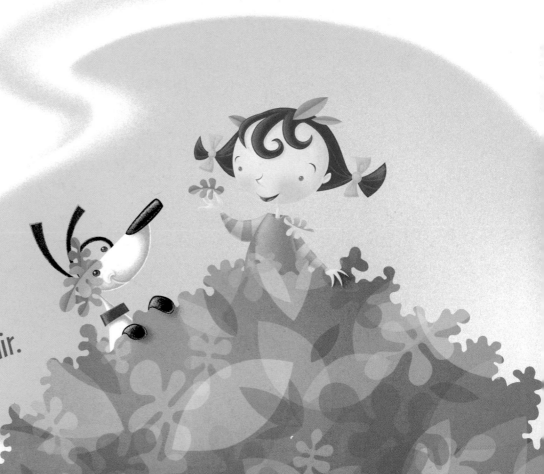

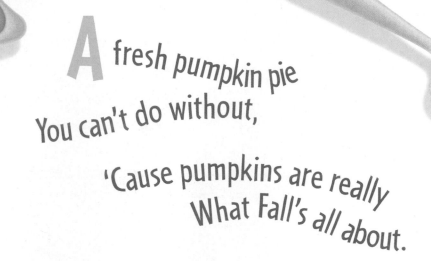

A fresh pumpkin pie
You can't do without,

'Cause pumpkins are really
What Fall's all about.

To Sally and Sam
It's a scrumptious Fall dream,

With cinnamon, sugar
And lots of whipped cream.

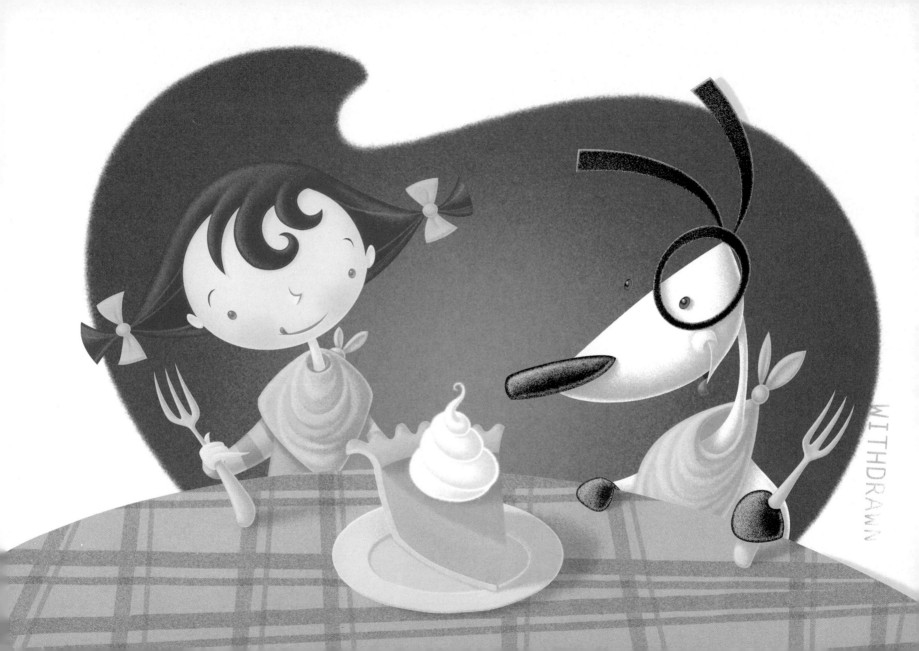

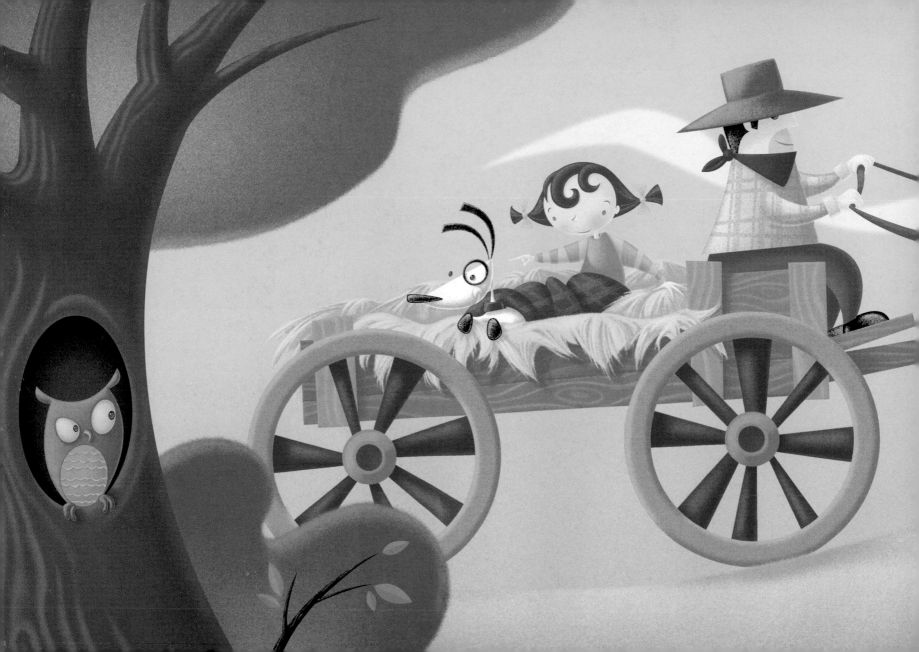

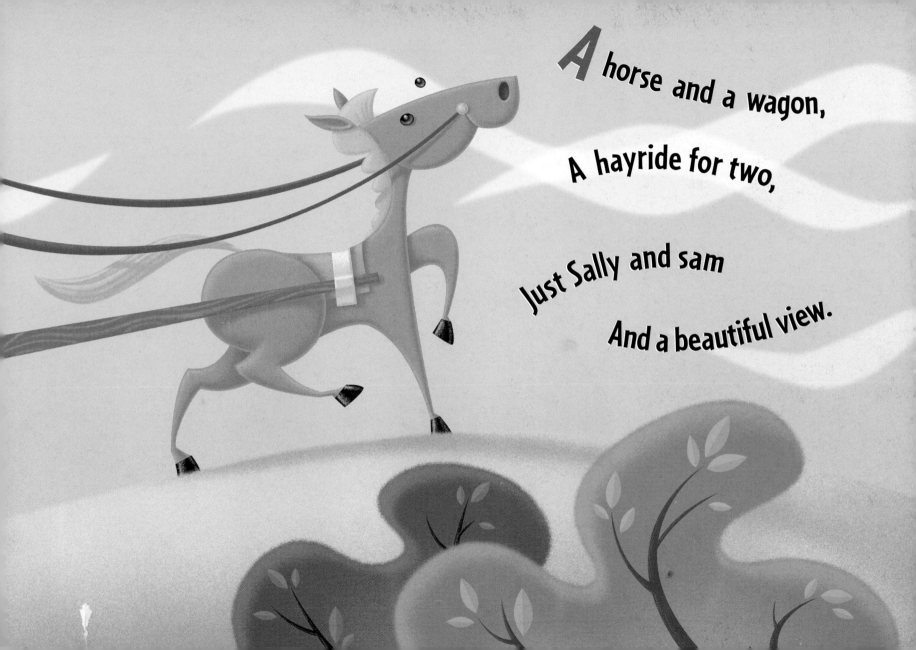

A horse and a wagon,

A hayride for two,

Just Sally and sam

And a beautiful view.

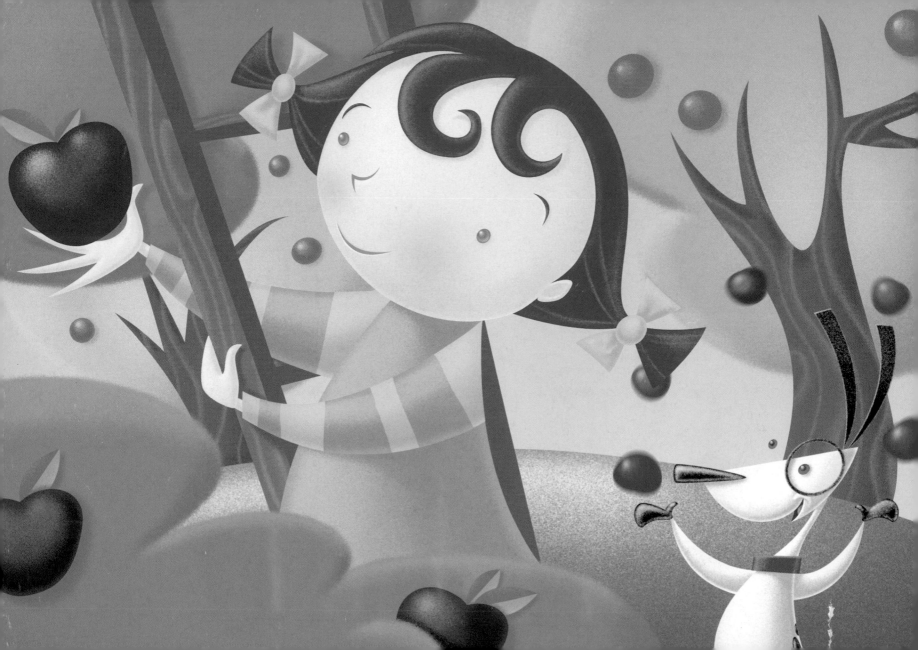

A trip to the orchard
 Is part of the fun.
They pick ripe, red apples
 In warm Autumn's sun.

Filling containers
With Fujis galore,
They stop when their baskets
Can't hold any more.

The old County Fair
Comes around every year,
With rides, food and games
And endless good cheer.

The Fair offers everyone so much to do

They start at the little animal zoo.

Sally feeds chicks from a tiny tin pail;

Sam learns he must keep an eye on his tail.

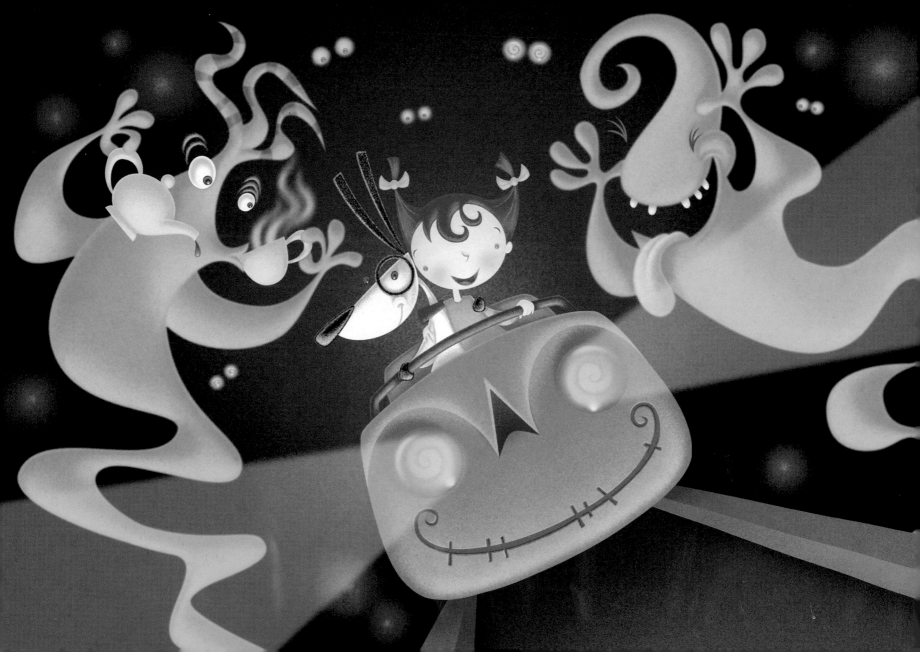

Of course, with the Fair

Comes a Haunted House ride.

It's best to have someone

You like by your side.

Fall's the main season
 To carve pumpkin art,

So Sally and Sam will, of course,
 Do their part.

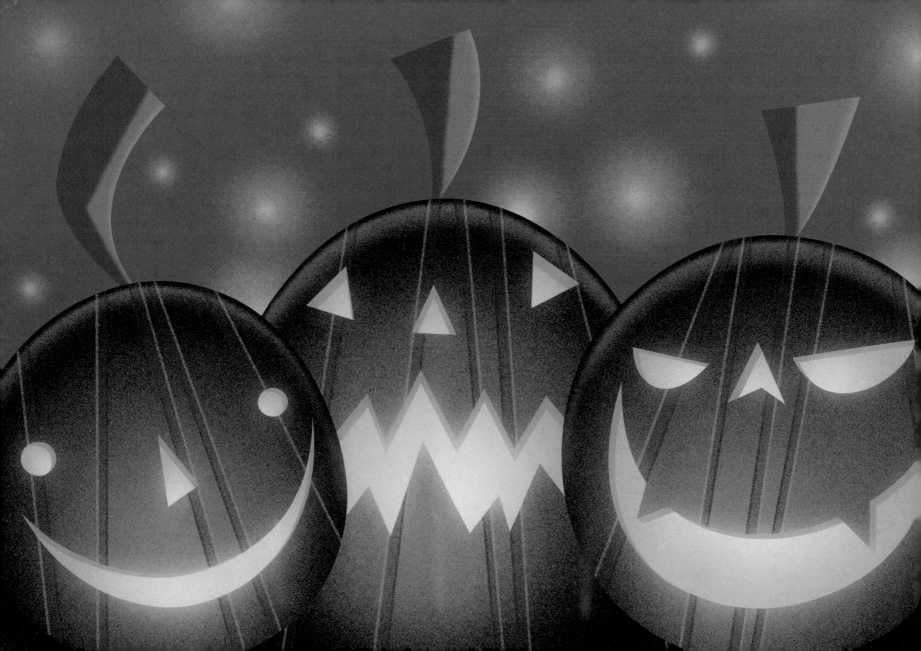

Their pumpkins are finished;
The carving's complete.

They turn out the light -
A **spook-tacular** treat!

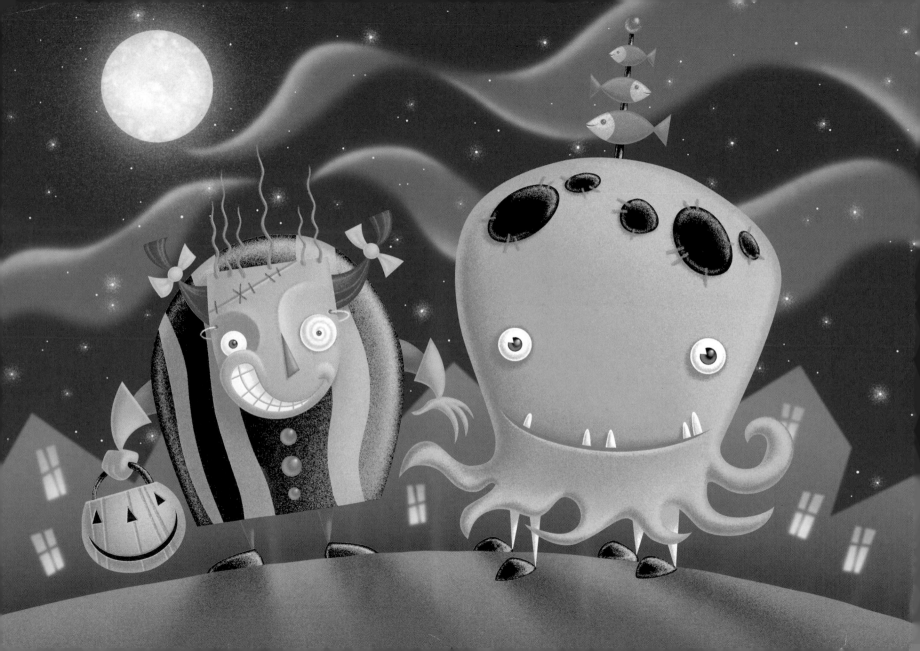

They work on their costumes;
Wow, what a fright.

Sally's a ghoul
For this Halloween night.

Sam is an octopus -
All arms and no mitts -
He's ready to scare

People out of their wits.

Bobbing for apples
Is such a great game.

It takes special skill
And real water aim.

With all the fun over,
They're ready to go.

Sam laughs at Sally
Who's wet head to toe.

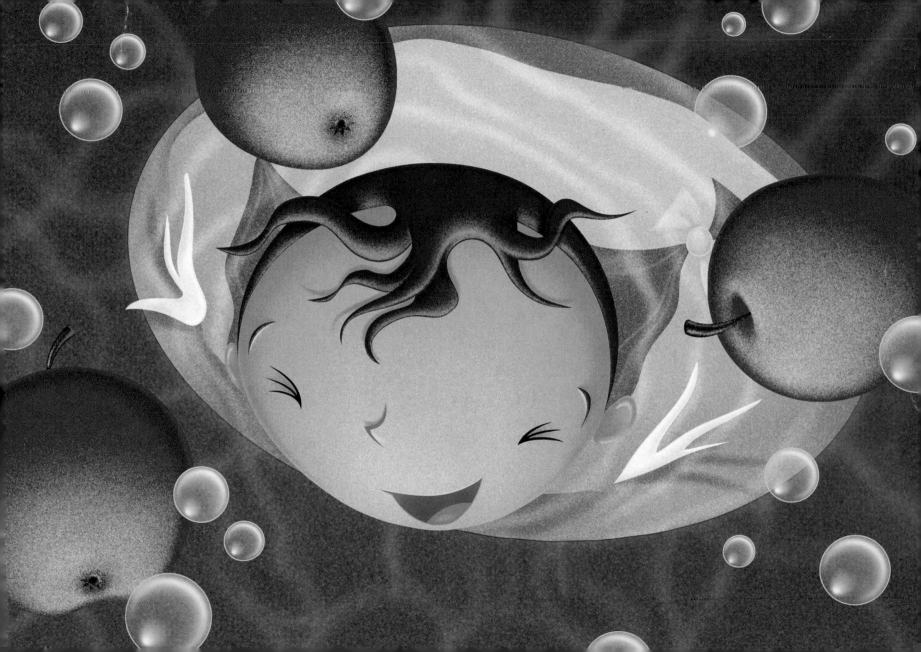

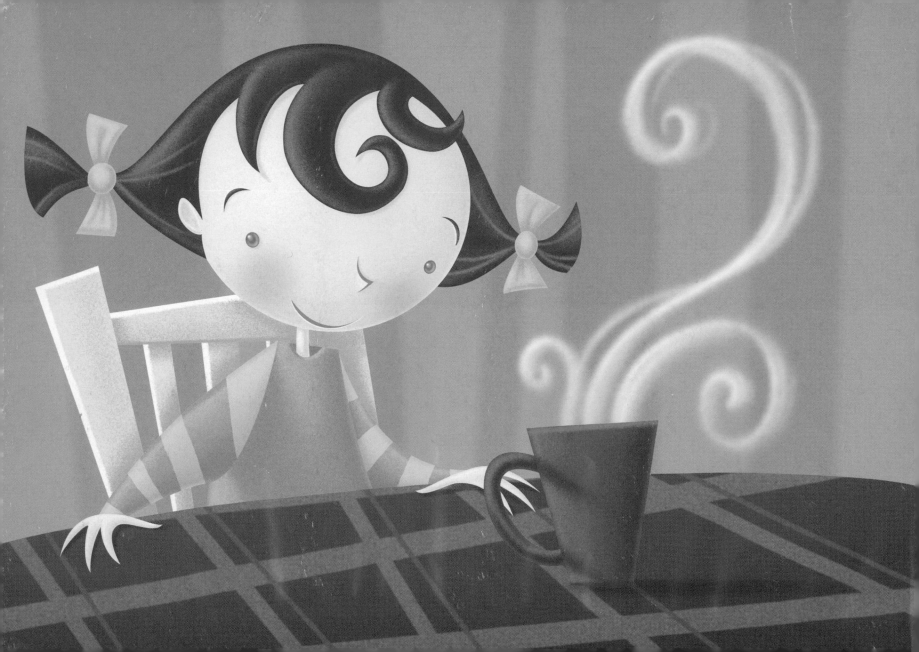

To warm yourself up

On a cold Autumn day,

Hot cider's the thing

To chase shivers away.

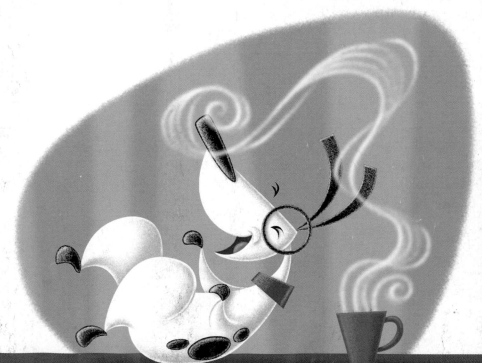

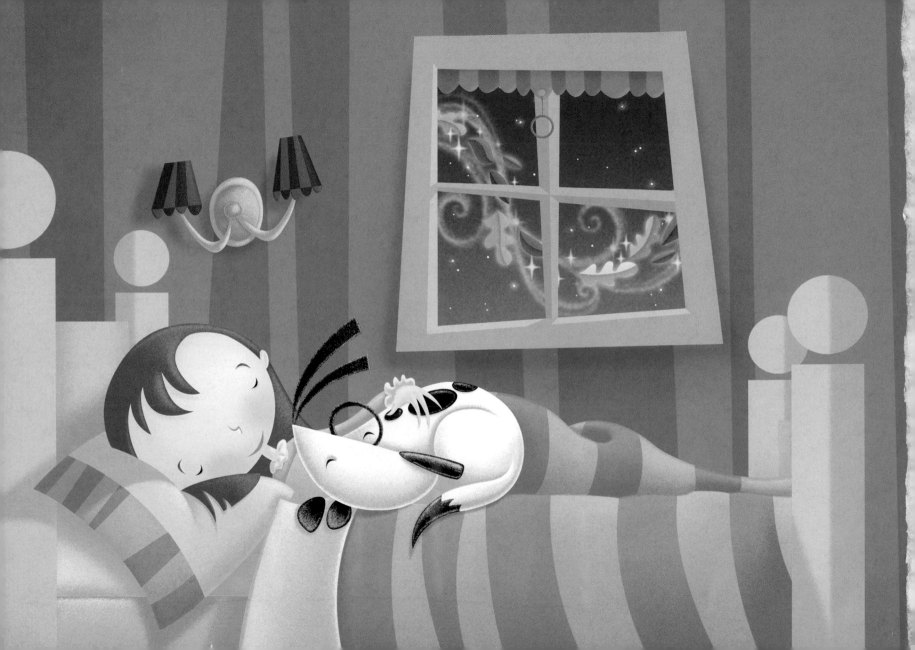

Now snuggled in bed,
On this first night of Fall,

They cannot believe
They're so tired from it all.

But weary or not,
They are happy to see

How much fun the discov'ry
Of Autumn can be.

Published by
Smallfellow Press
A division of Tallfellow Press, Inc.
1180 S. Beverly Drive
Los Angeles, CA 90035

Type and Layout: Scott Allen

ISBN 1-931290-15-6

Printed in Italy
10 9 8 7 6 5 4 3 2 1

Tallfellow Press, Inc
Los Angeles